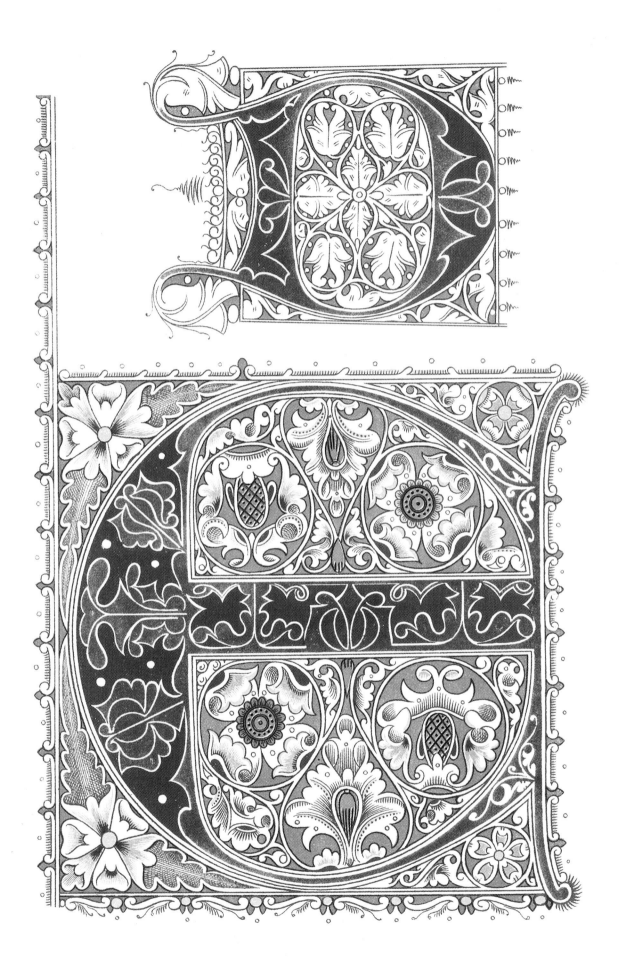

Fourteenth Century

Masterpieces of Illuminated Letters and Borders

W. R. TYMMS *AND* M. D. WYATT

DOVER PUBLICATIONS, INC.
Mineola, New York

Publisher's Note

Although the practice of decorating manuscripts is as old as writing itself, the European tradition of "illuminating" texts with vibrant colors and precious metals such as gold and silver remains a outstanding specimen of medieval design and layout. Unsurpassed in beauty, the illuminated manuscript is at once a unique, handmade object. The initials themselves almost disappear in the intricate ornamentation of intertwining foliage patterns, fantastic animal imagery, and even human figures.

A wondrous collection of ornamental letters and borders, the present volume reproduces, in full color, a selection of 58 plates from *The Art of Illuminating as Practised in Europe from the Earliest Times,* a rare, nineteenth-century classic reflecting the richness and diversity of this art form. Arranged chronologically, the book begins with decorative motifs from the sixth century, and spans through several centuries of time, up to the sixteenth century. Many of the designs in this book are also available on CD-ROM from Dover Publications in *Full-Color Illuminated Initials CD-ROM and Book* (ISBN 0-486-99587-9).

Copyright

Copyright © 2006 by Dover Publications, Inc.
All rights reserved.

Bibliographical Note

This Dover edition, first published in 2006, is a new selection of 58 plates from: *The Art of Illuminating as Practised in Europe from the Earliest Times, Illustrated by Borders, Initial Letters, and Alphabets* / Selected & Chromolithographed by W. R. Tymms; With an Essay and Instructions by M. D. Wyatt, originally published by Day and Son, Lithographers to the Queen, London, in 1860.

DOVER *Pictorial Archive* SERIES

Library of Congress Cataloging-in-Publication Data

Tymms, W. R. (William Robert)
 Masterpieces of illuminated letters and borders / W.R. Tymms and M.D. Wyatt.
 p. cm. — (Dover pictorial archive series)
 Selection of plates from: The art of illuminating as practised in Europe from the earliest times, illustrated by borders, initial letters, and alphabets. London : Day and Son, Lithographers to the Queen, 1860.
 New selection of 58 plates selected & chromolithographed by W.R. Tymms, with an essay and instructions by M.D. Wyatt.
 ISBN 0-486-44784-7 (pbk.)
 1. Illumination of books and manuscripts—Themes, motives. 2. Borders, Ornamental (Decorative arts). 3. Initials. 4. Alphabets. I. Wyatt, M. Digby (Matthew Digby), Sir, 1820–1877. II. Art of illuminating as practised in Europe from the earliest times, illustrated by borders, initial letters, and alphabets. Selections. III. Title. IV. Series.

ND3310.T96 2006
745.6'7—dc22

2005055974

Manufactured in the United States of America
Dover Publications, Inc., 31 East 2nd Street, Mineola, N.Y. 11501

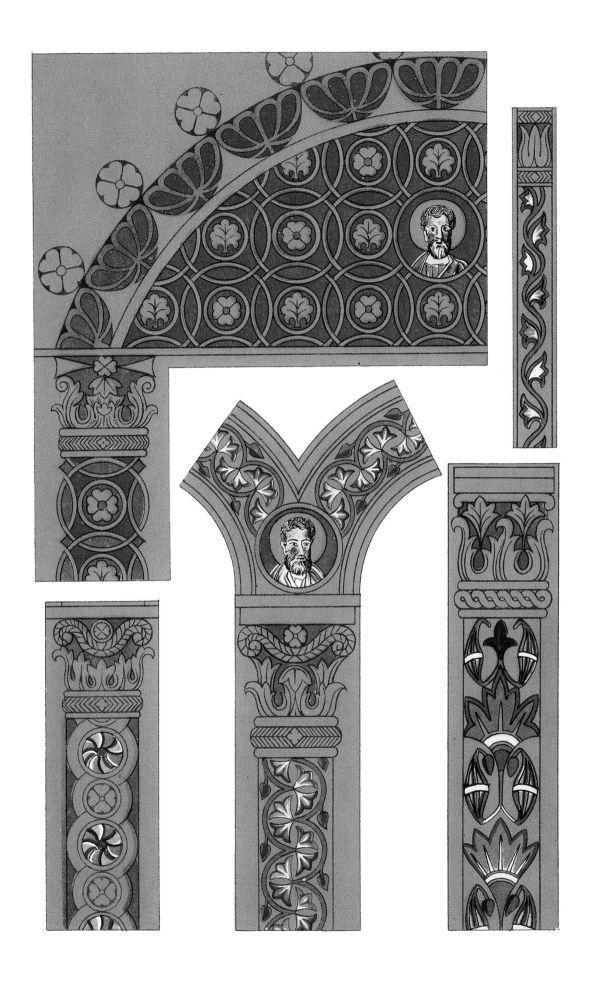

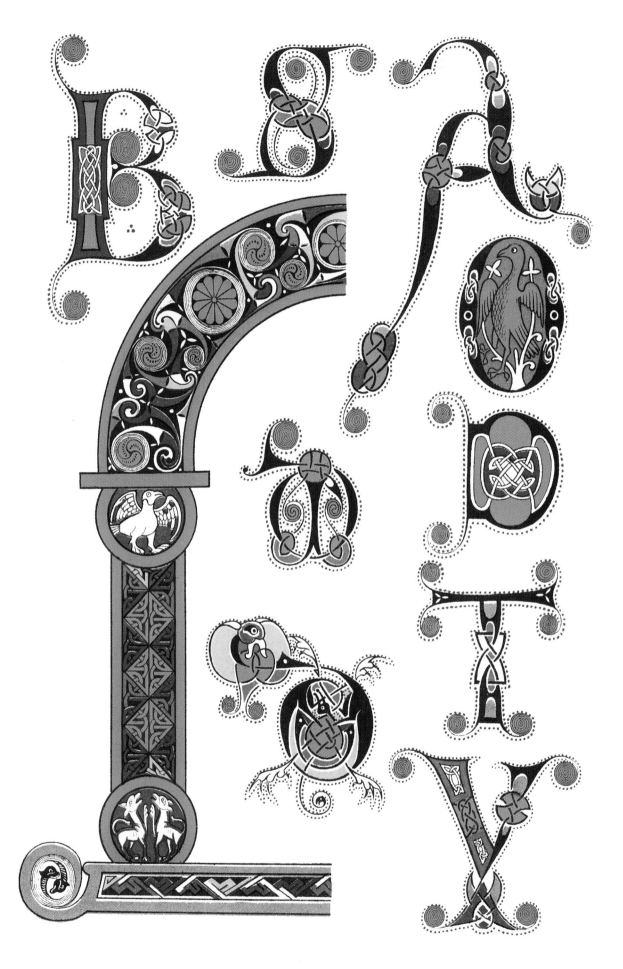

Plate 2 *Seventh Century*

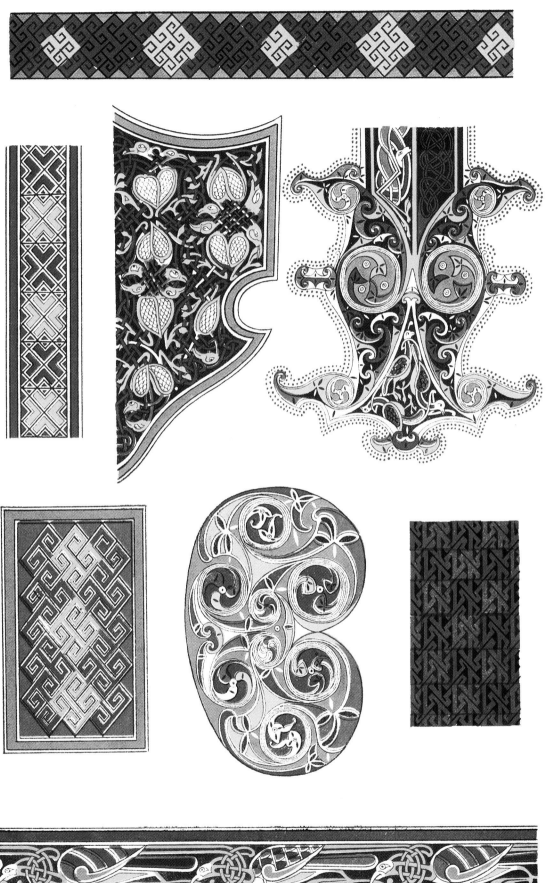

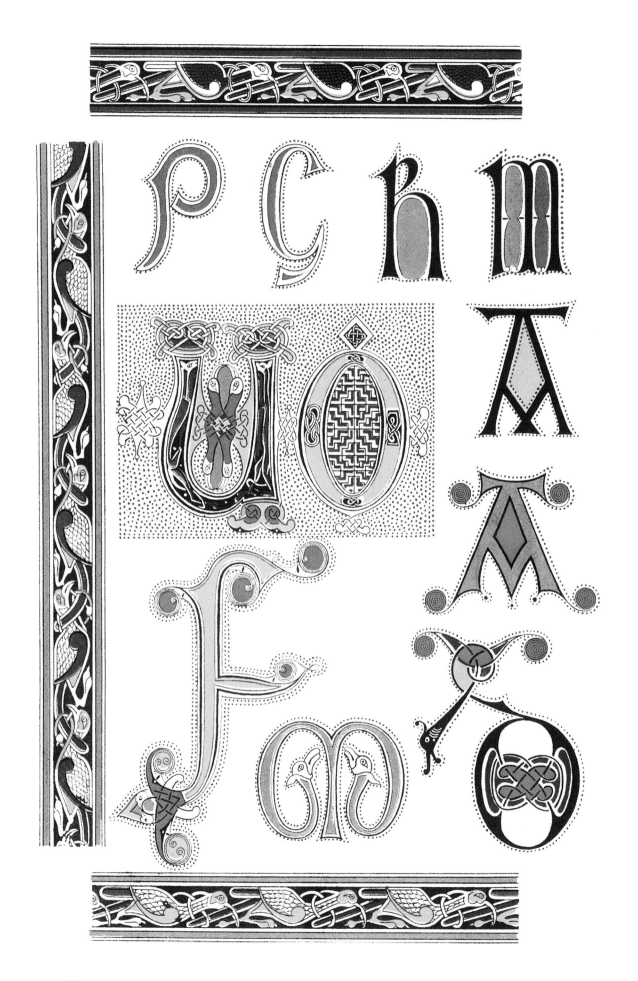

Plate 4 *Seventh Century*

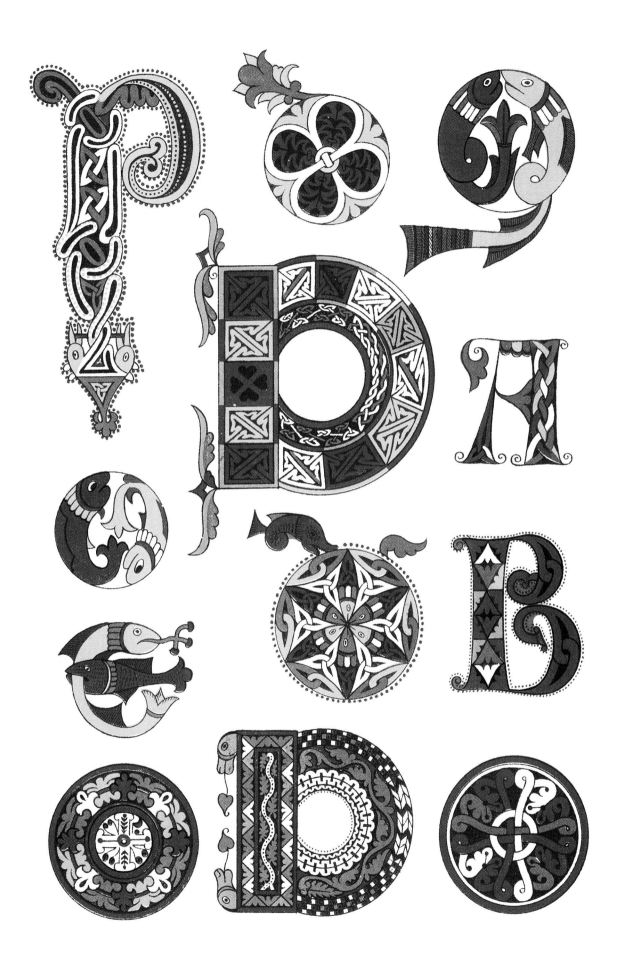

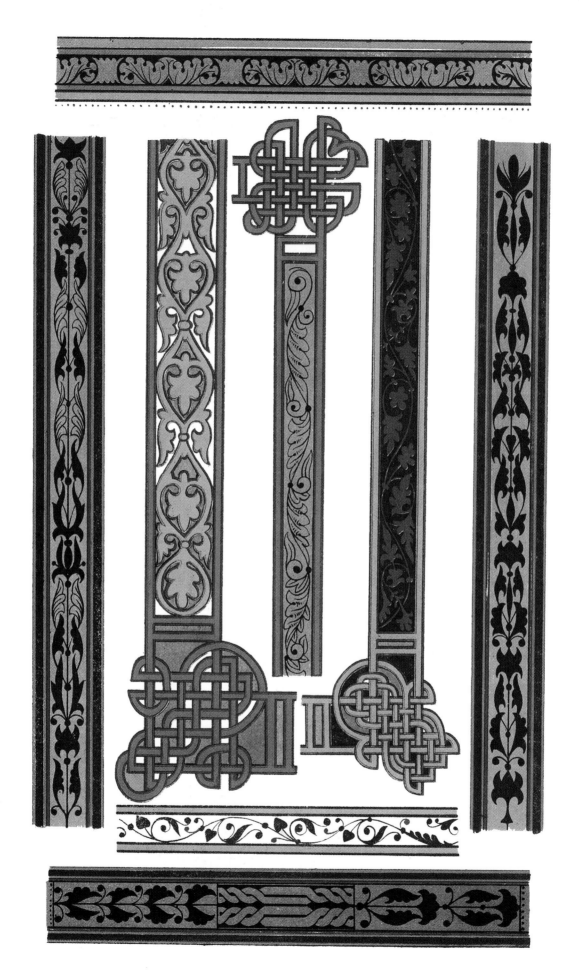

Plate 6　*Ninth Century*

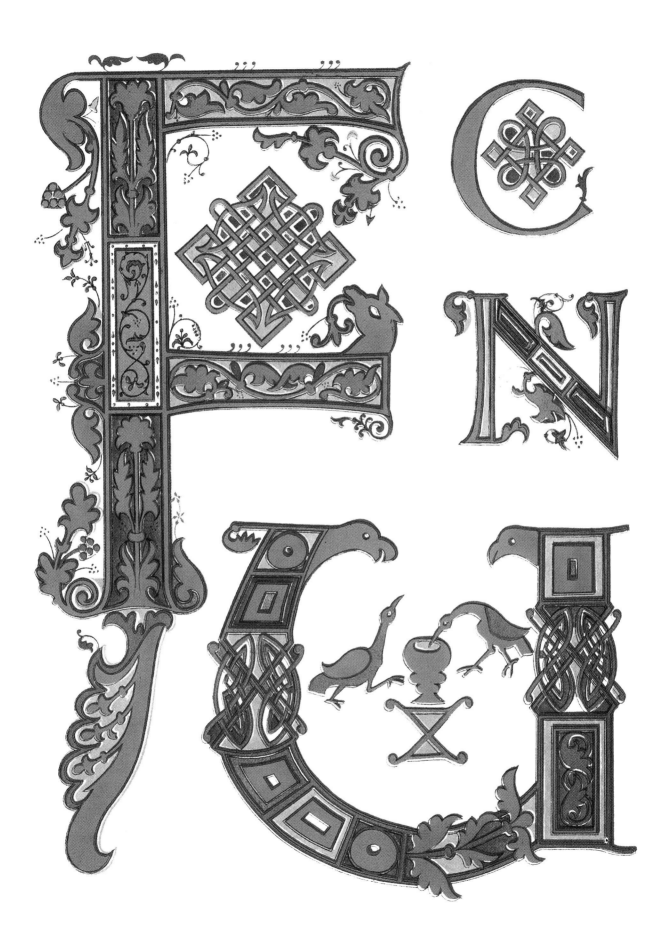

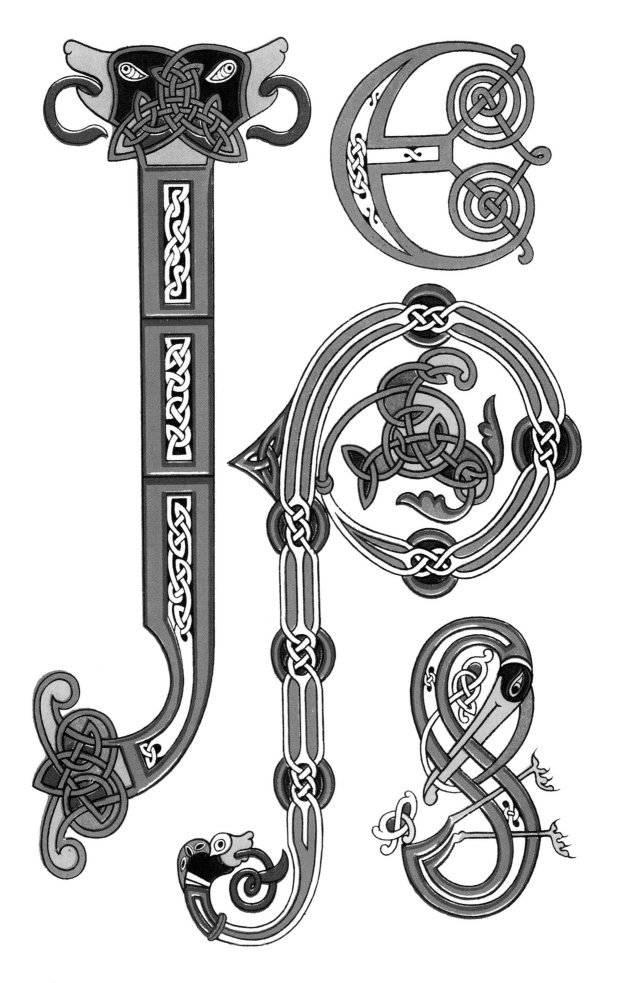

Plate 8 *Tenth Century*

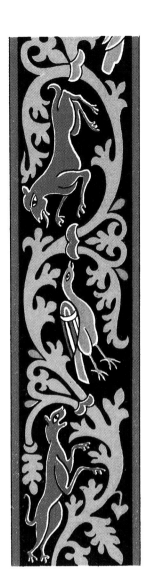
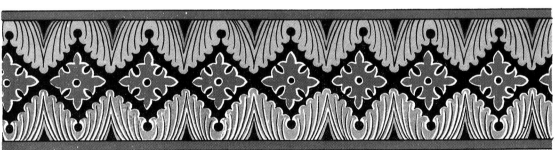
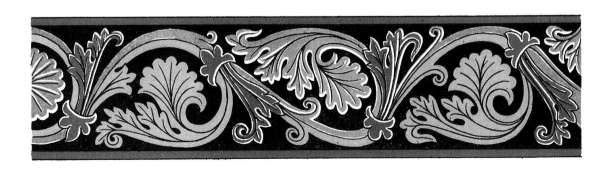

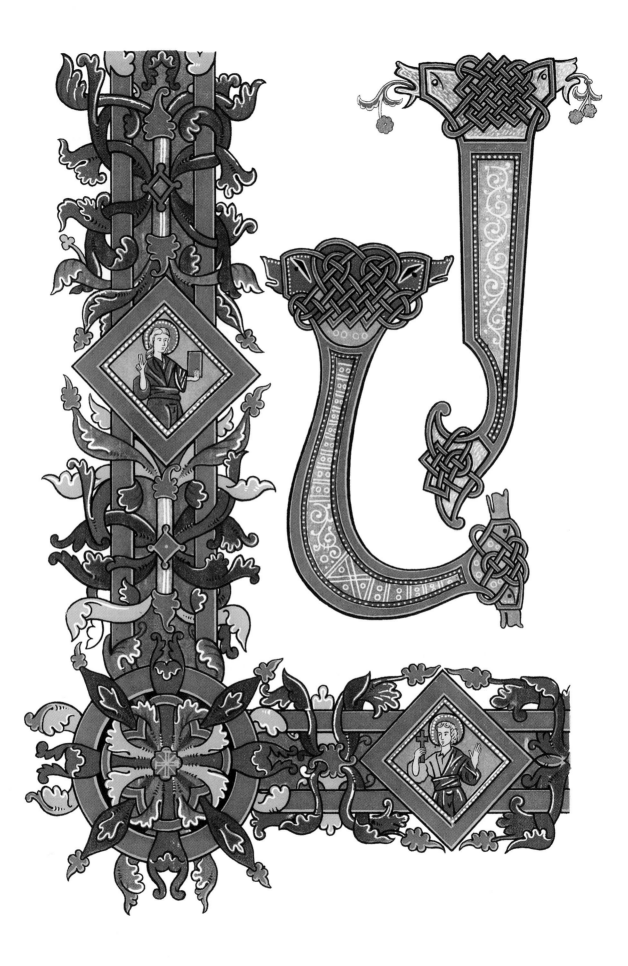

Plate 10 *Tenth Century*

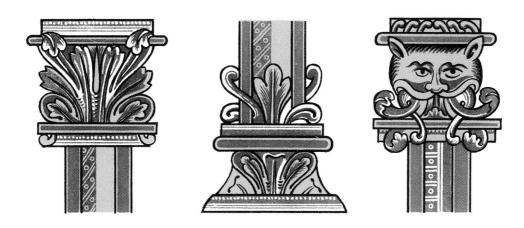

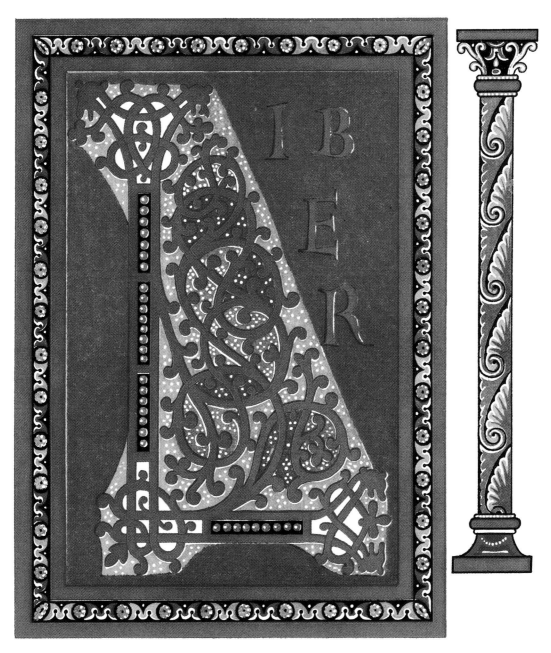

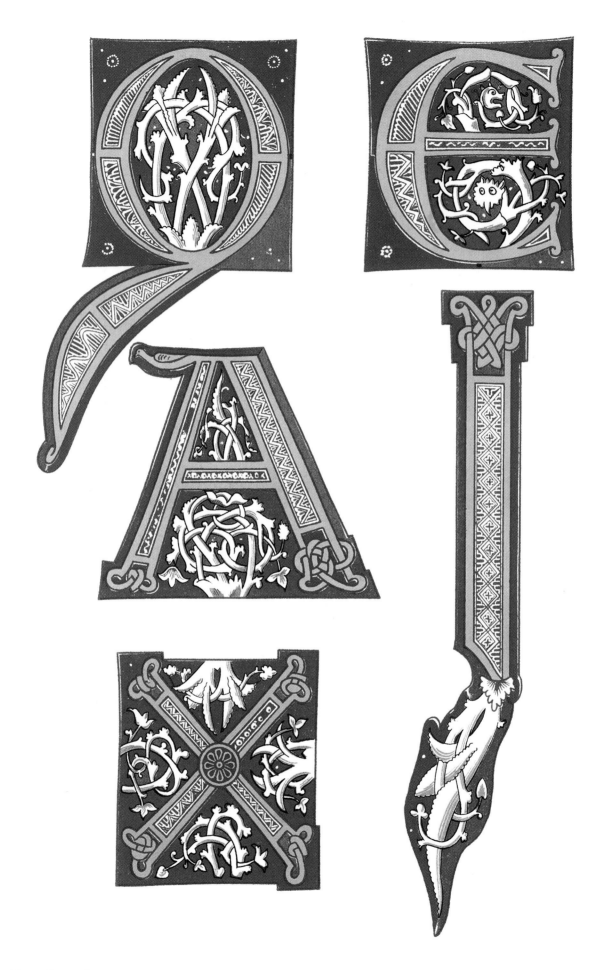

Plate 12 *Eleventh Century*

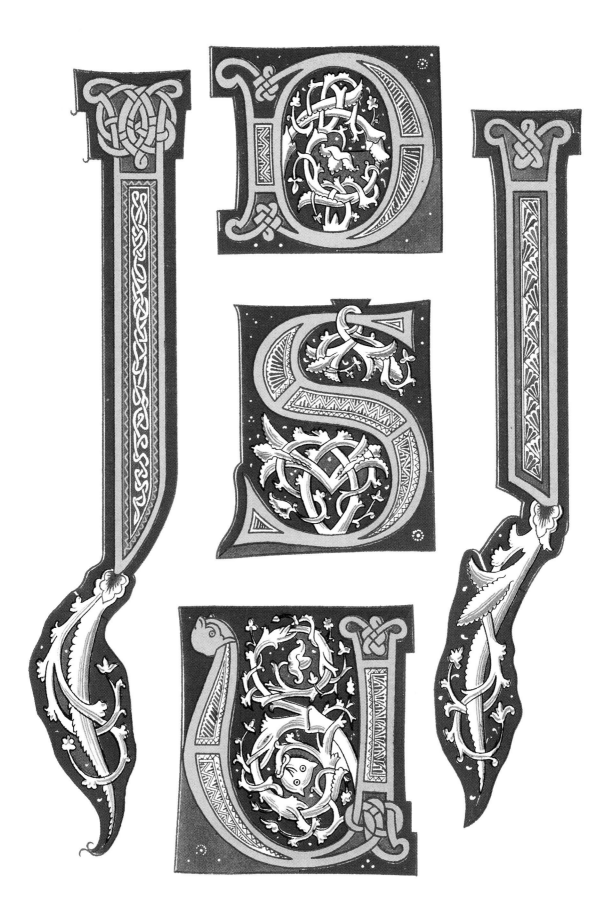

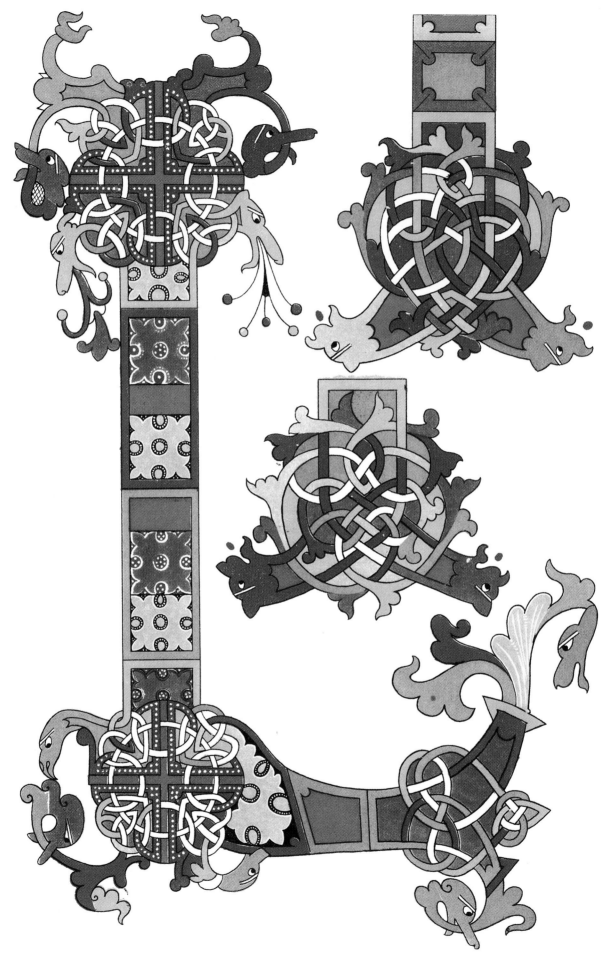

Plate 14 *Eleventh Century*

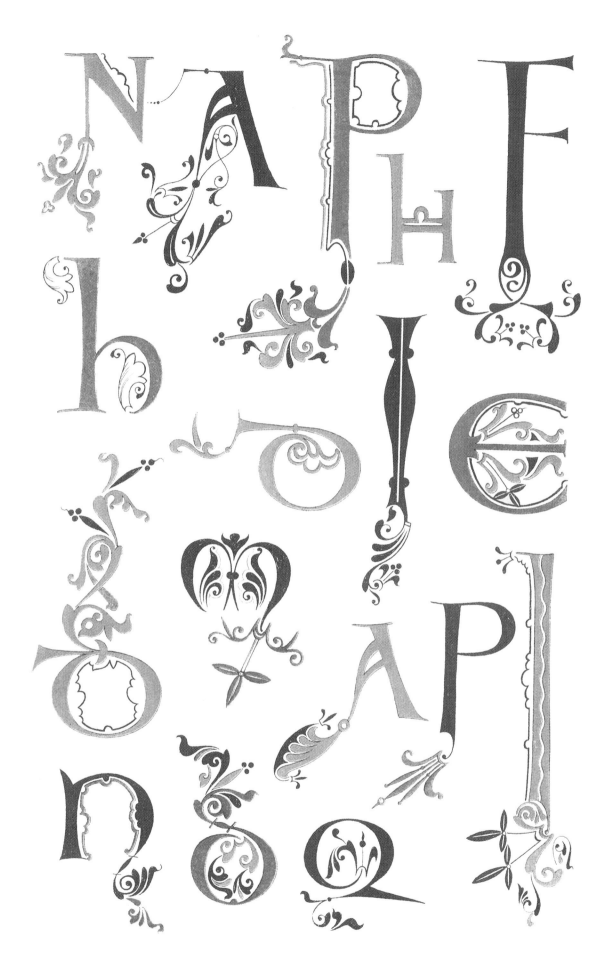

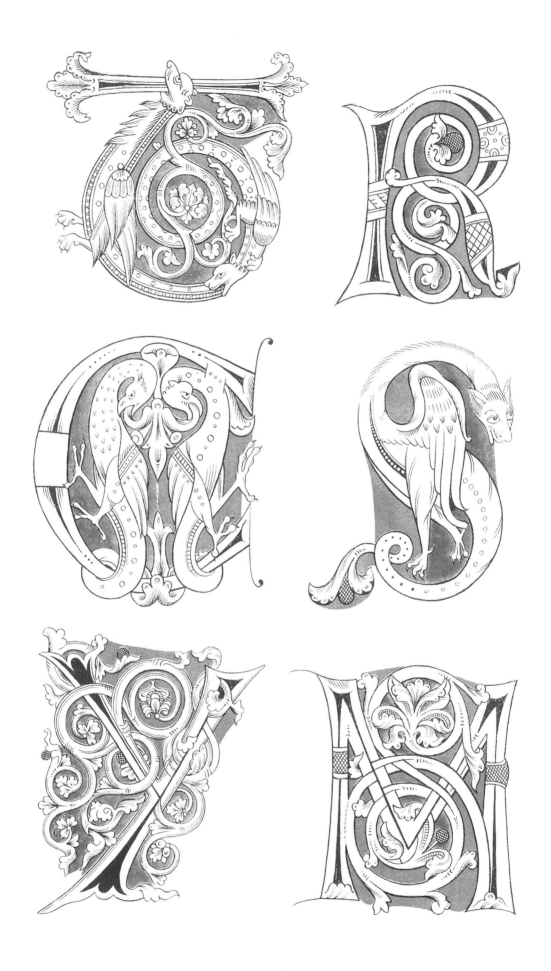

Plate 16 *Twelfth Century*

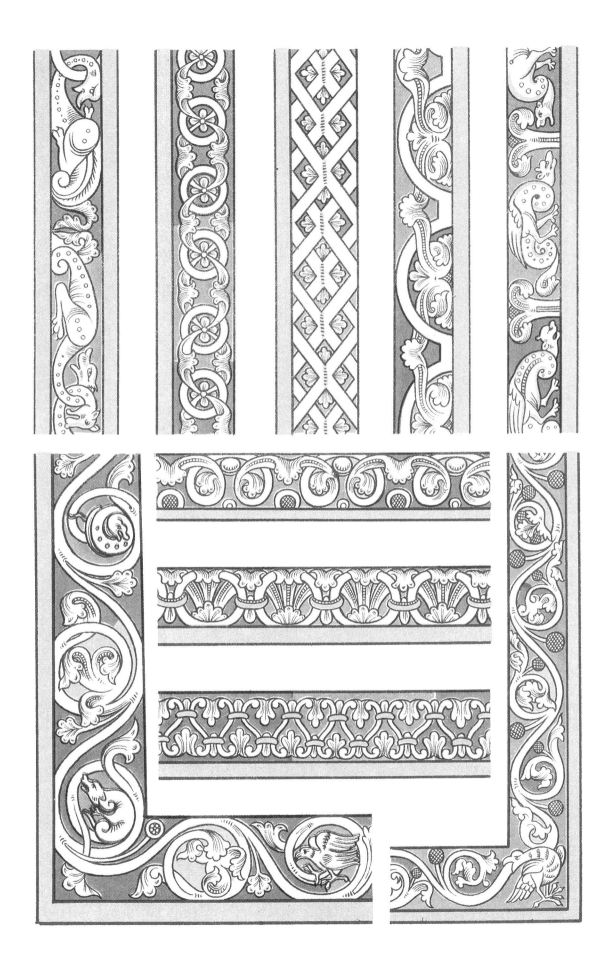

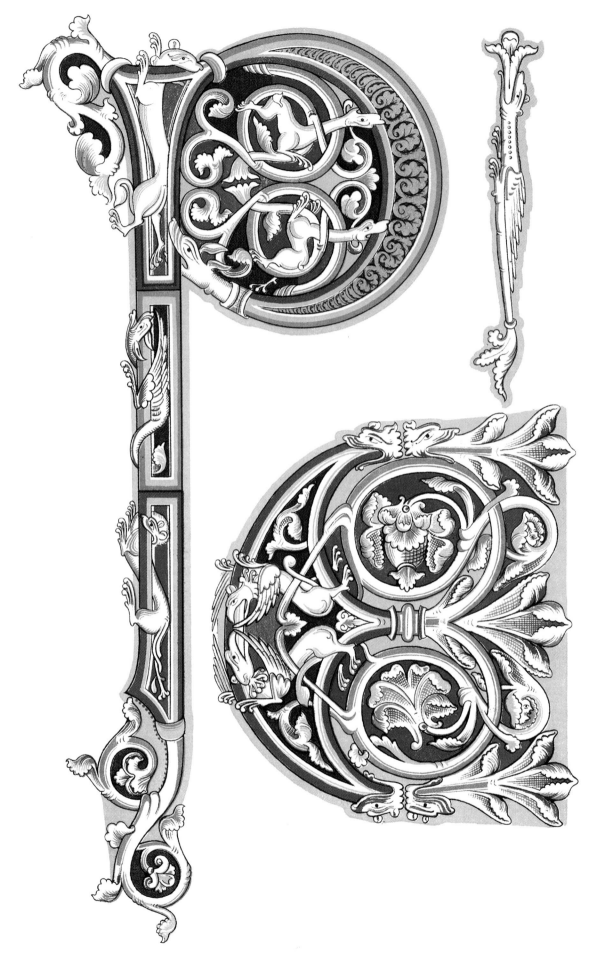

Plate 18 *Twelfth Century*

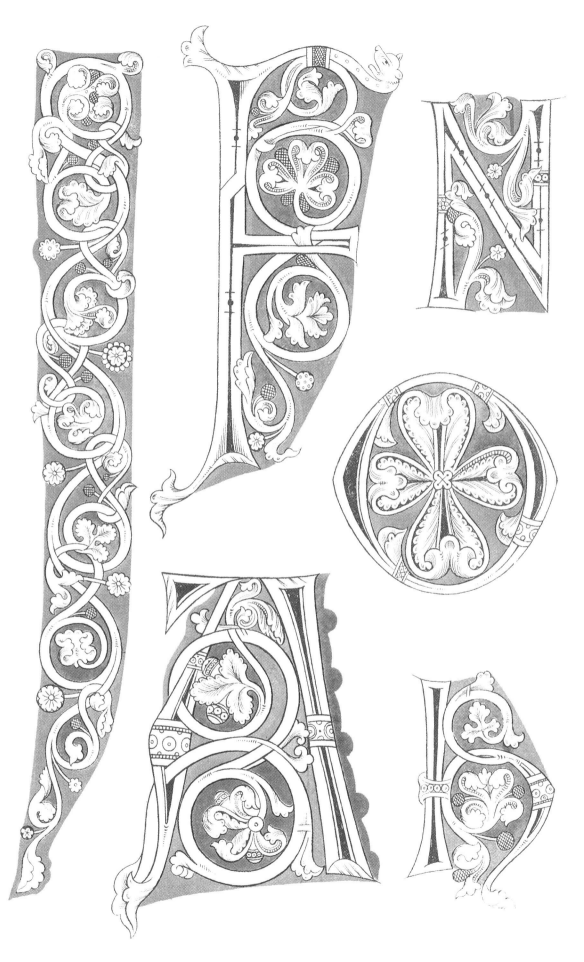

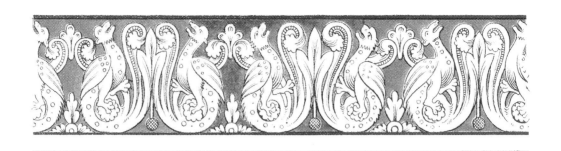

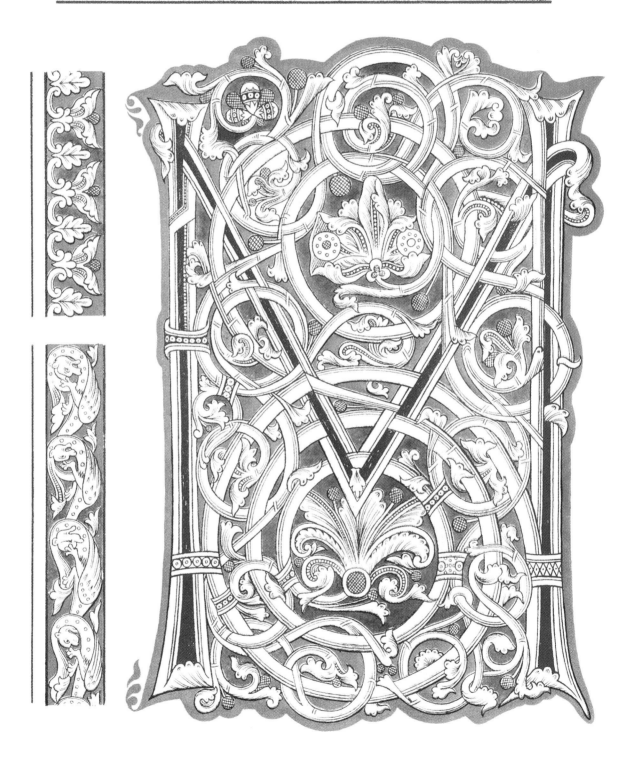

Plate 20 *Twelfth Century*

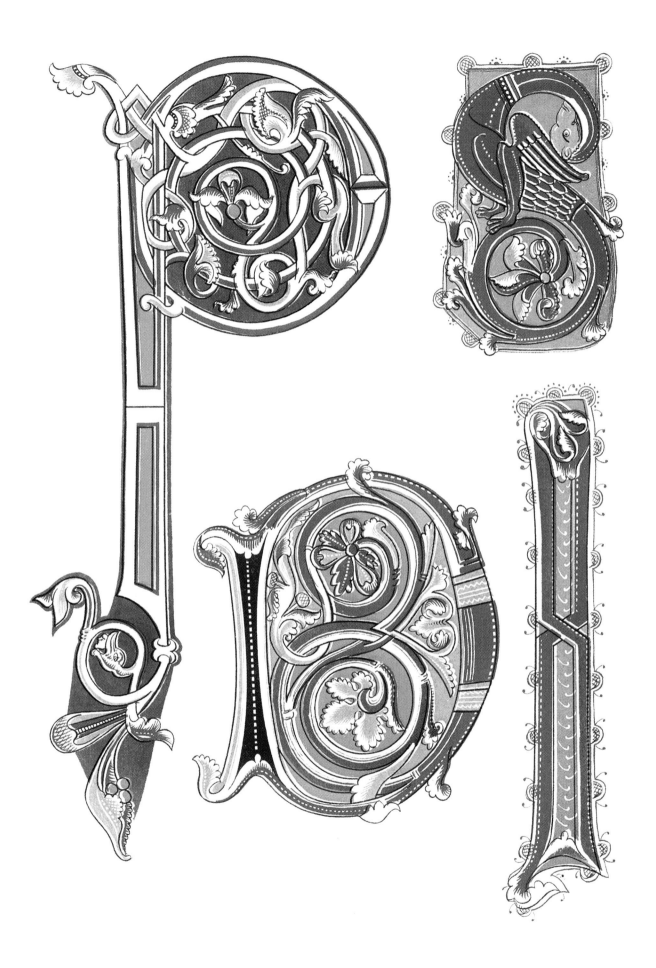

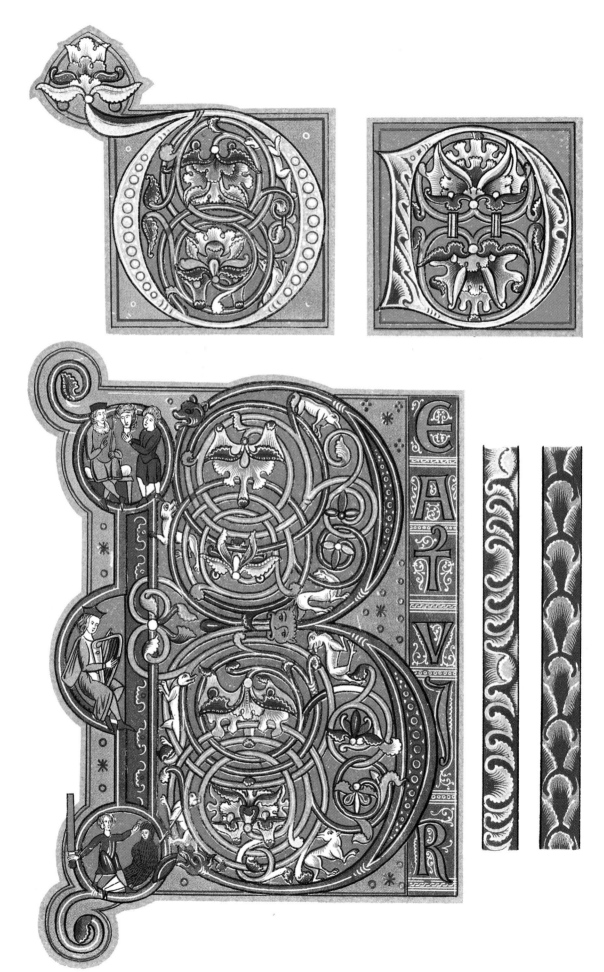

Plate 22 *Twelfth Century*

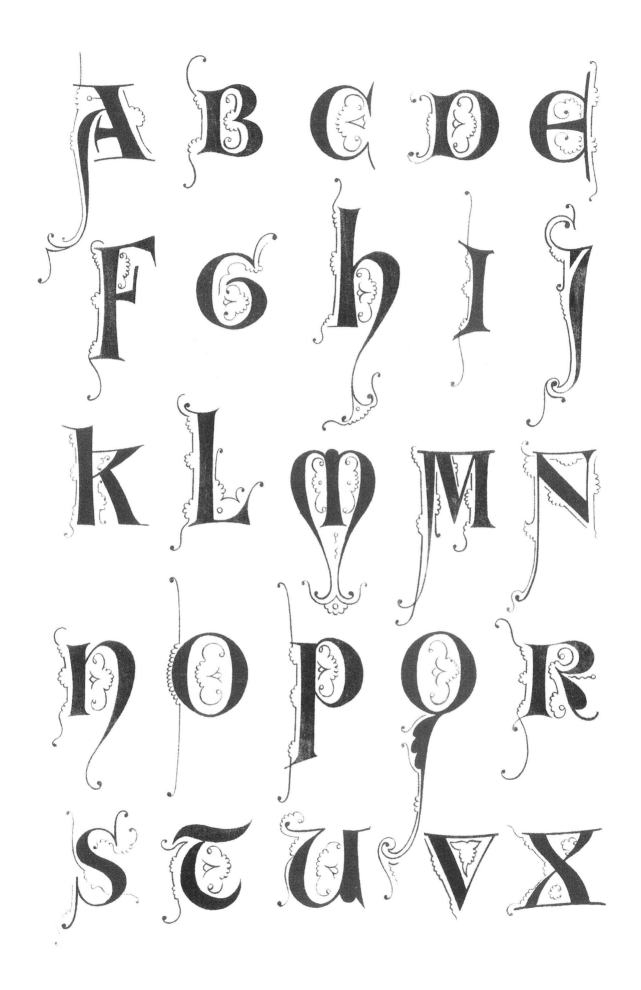

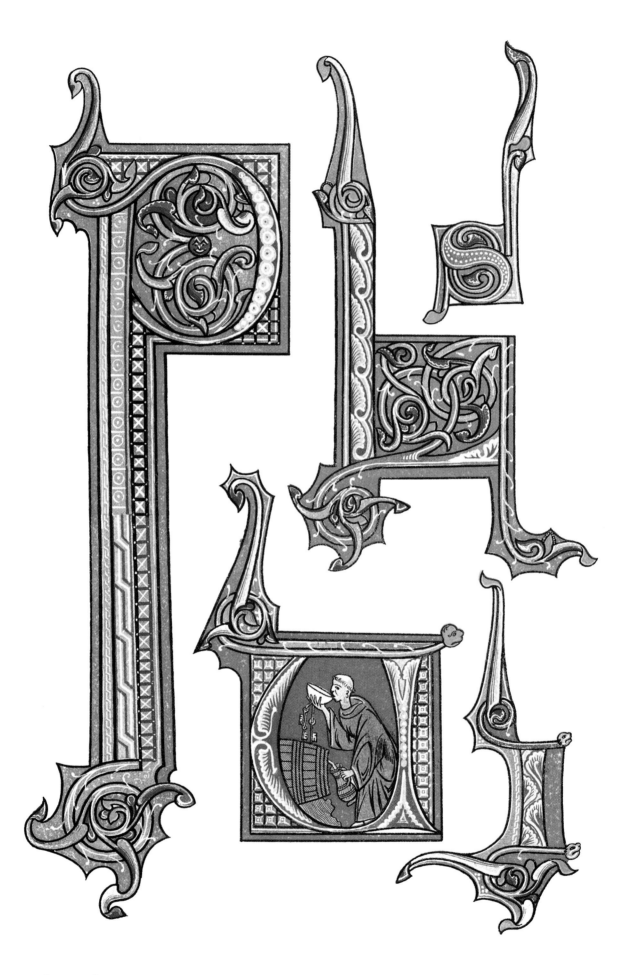

Plate 24 *Thirteenth Century*

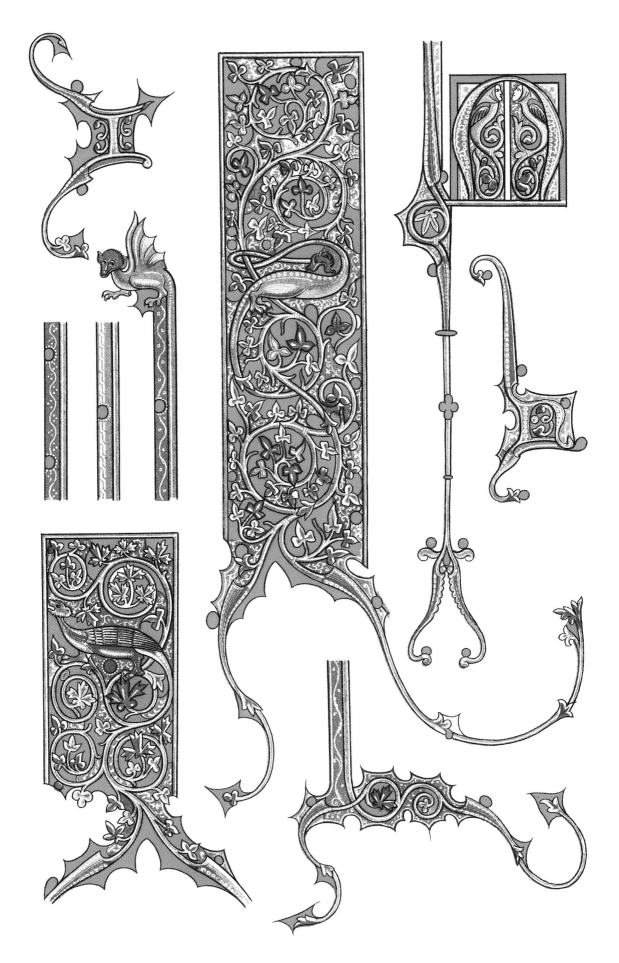

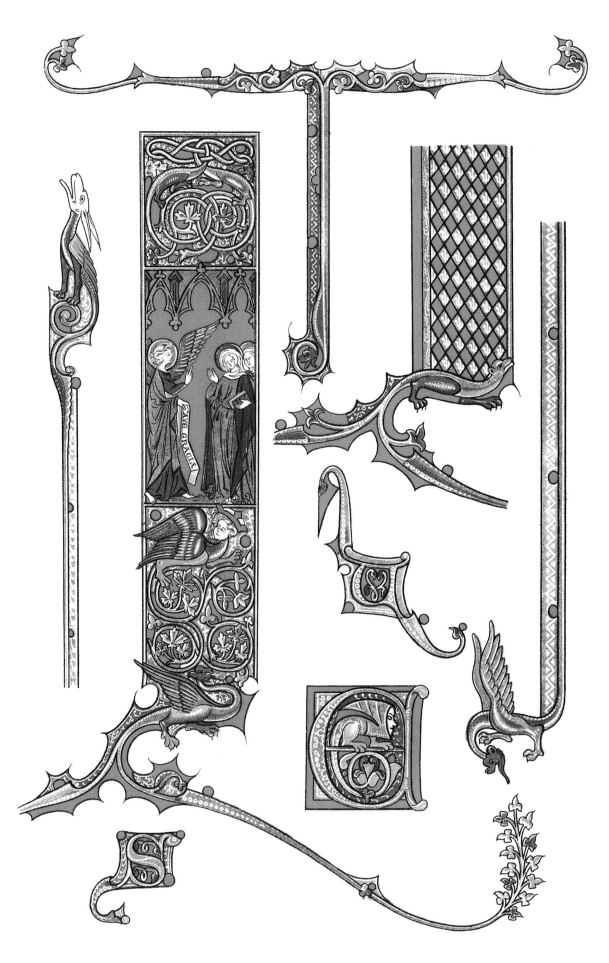

Plate 26 *Thirteenth Century*

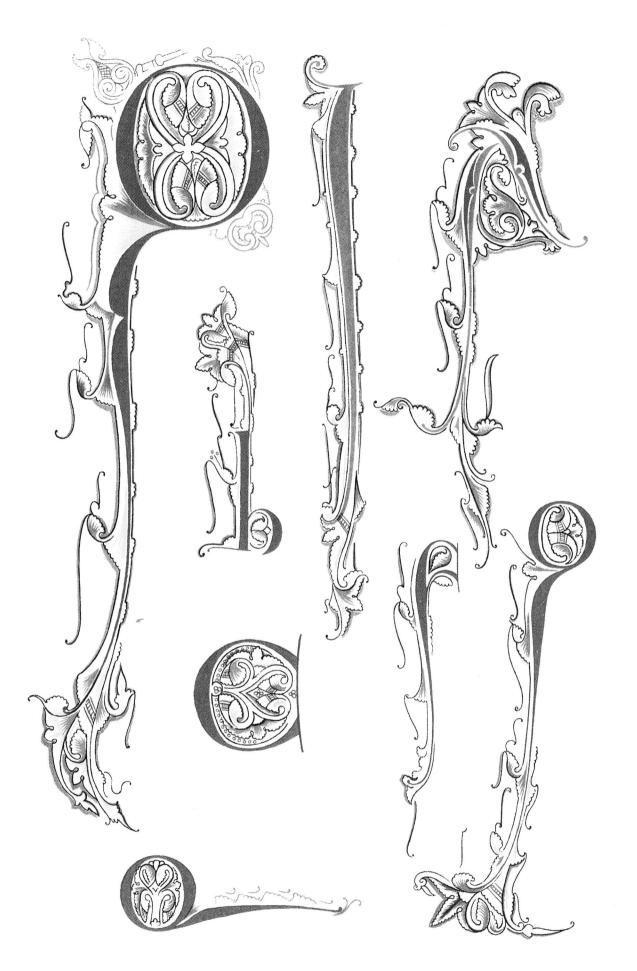

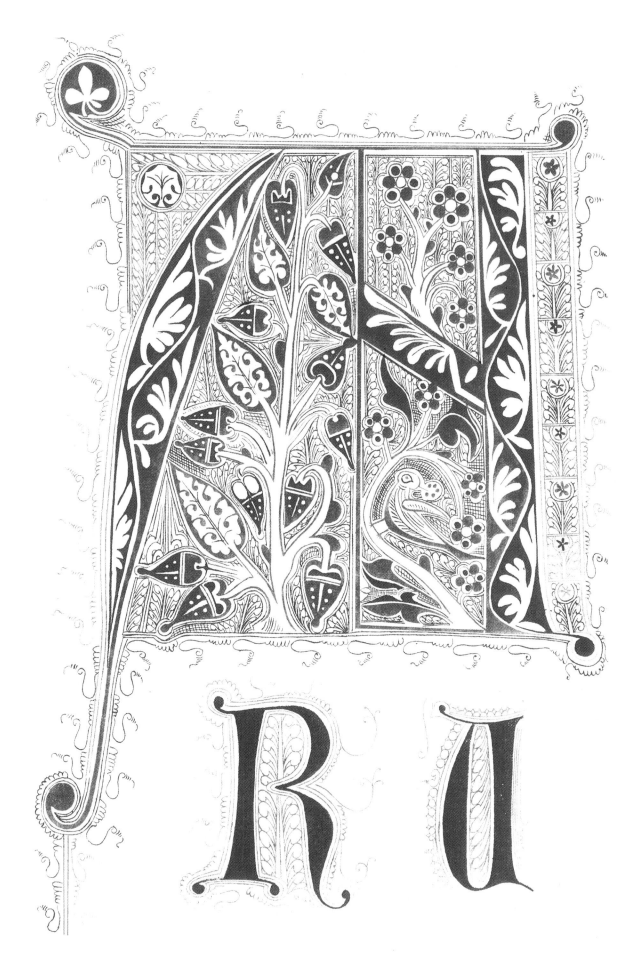

Plate 28　*Fourteenth Century*

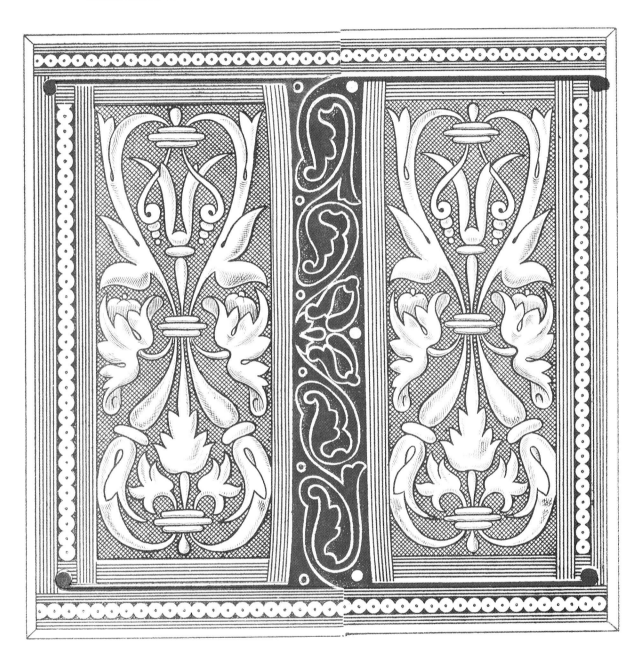

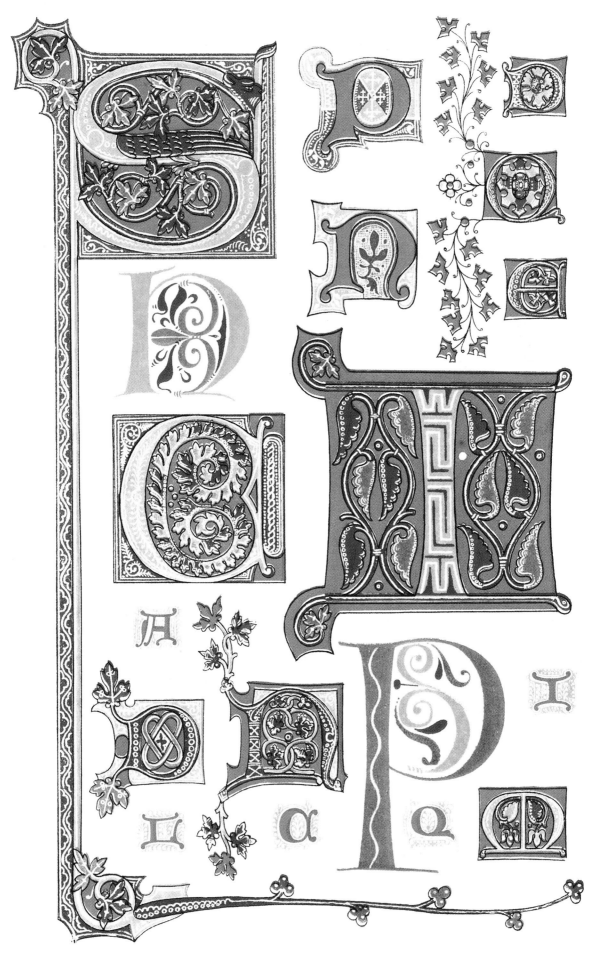

Plate 30 *Fourteenth Century*

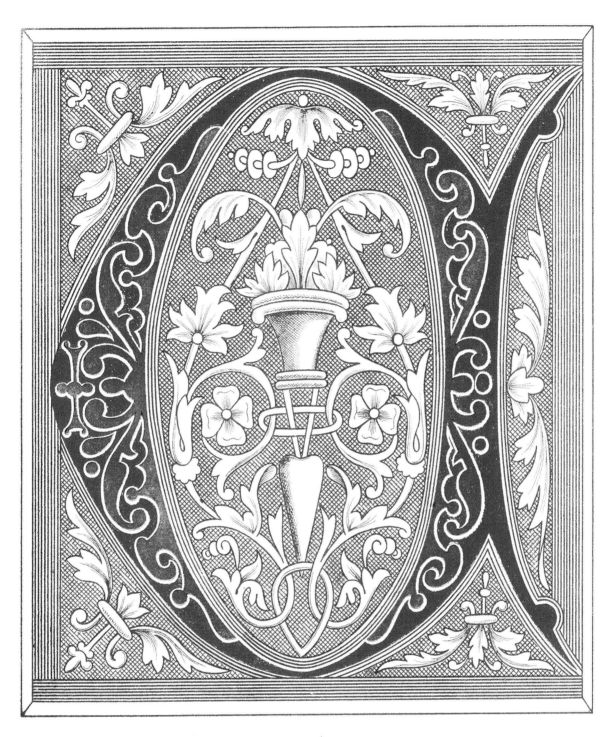

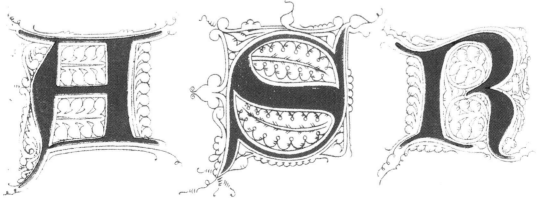

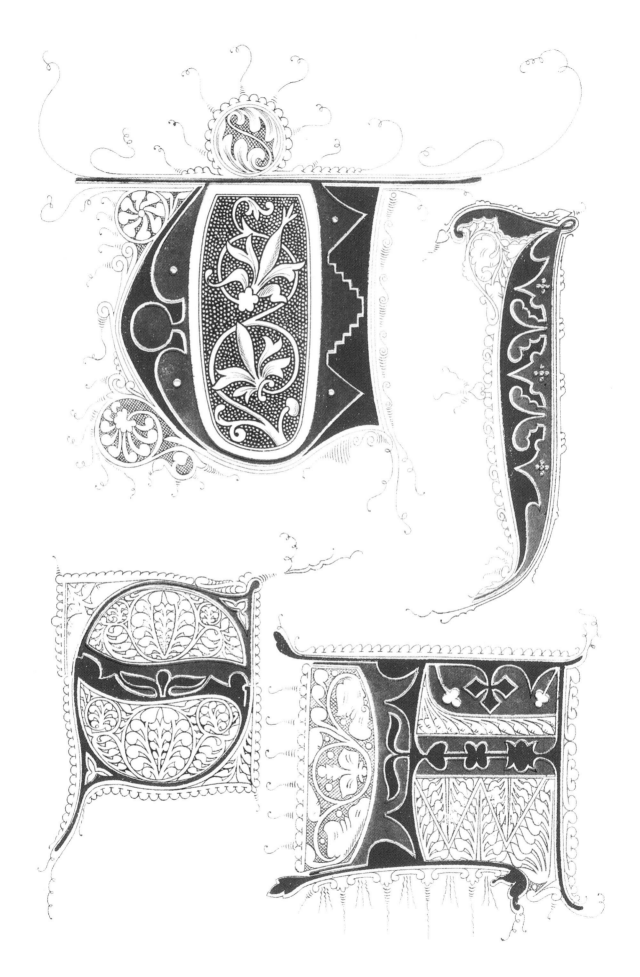

Plate 32 *Fourteenth Century*

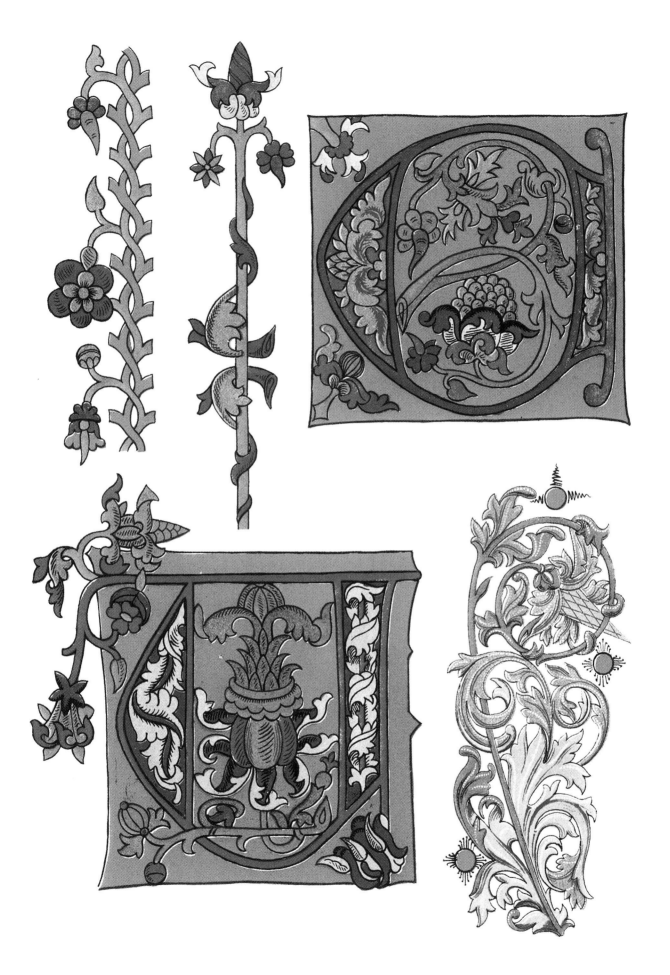

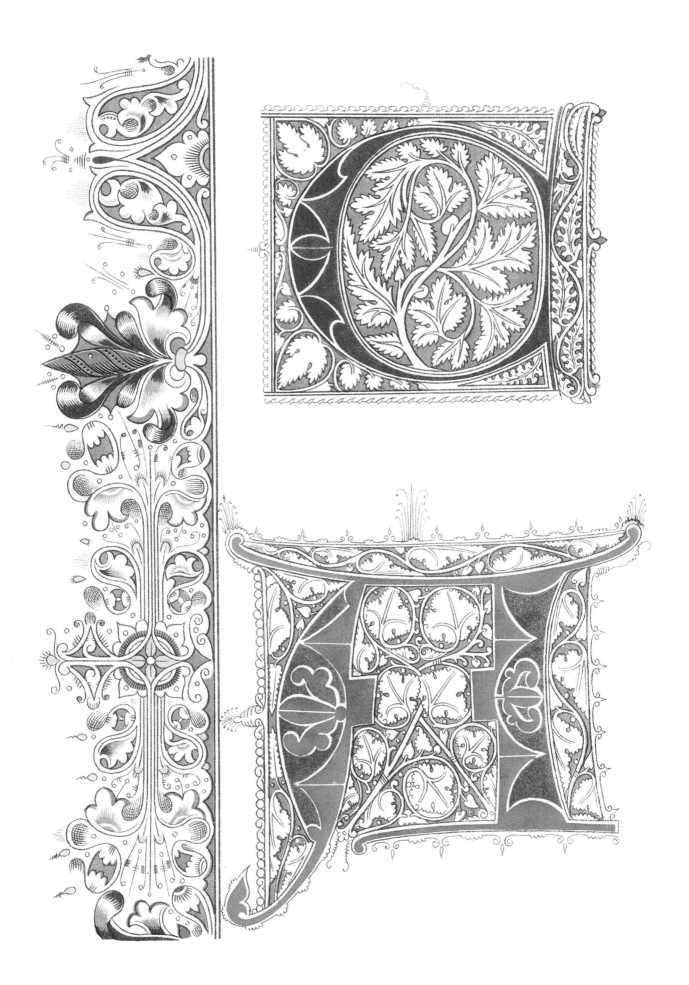

Plate 34 *Fourteenth Century*

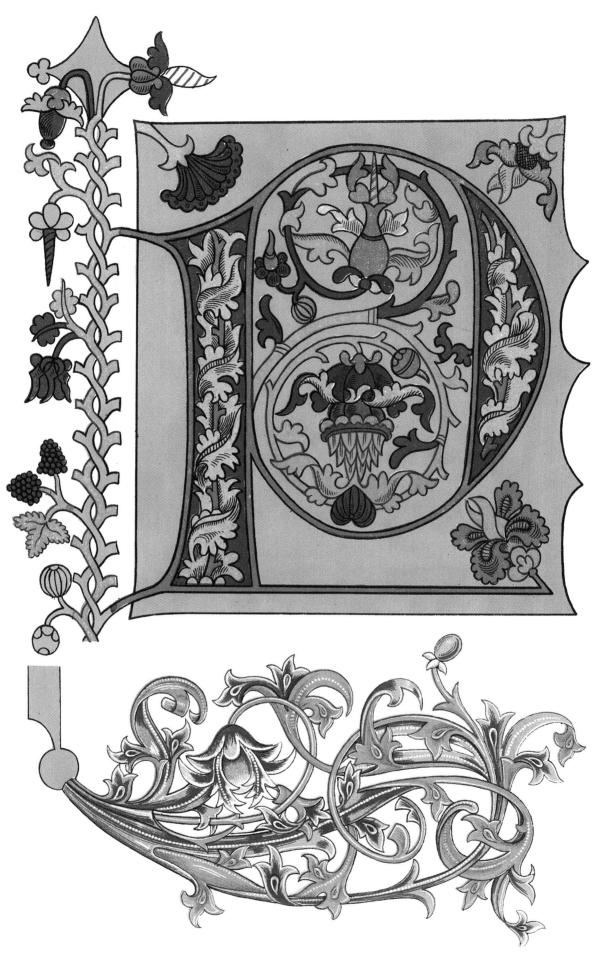

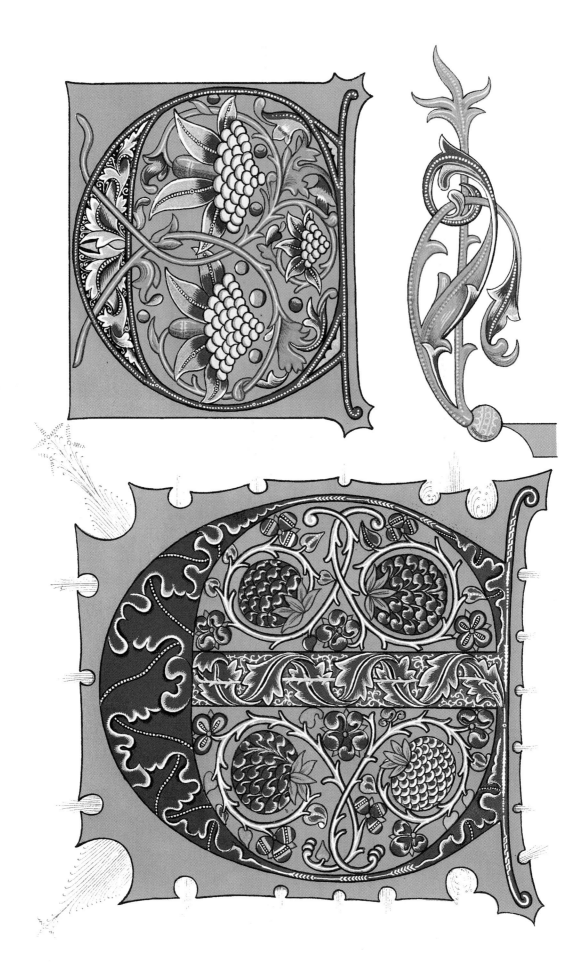

Plate 36 *Fourteenth Century*

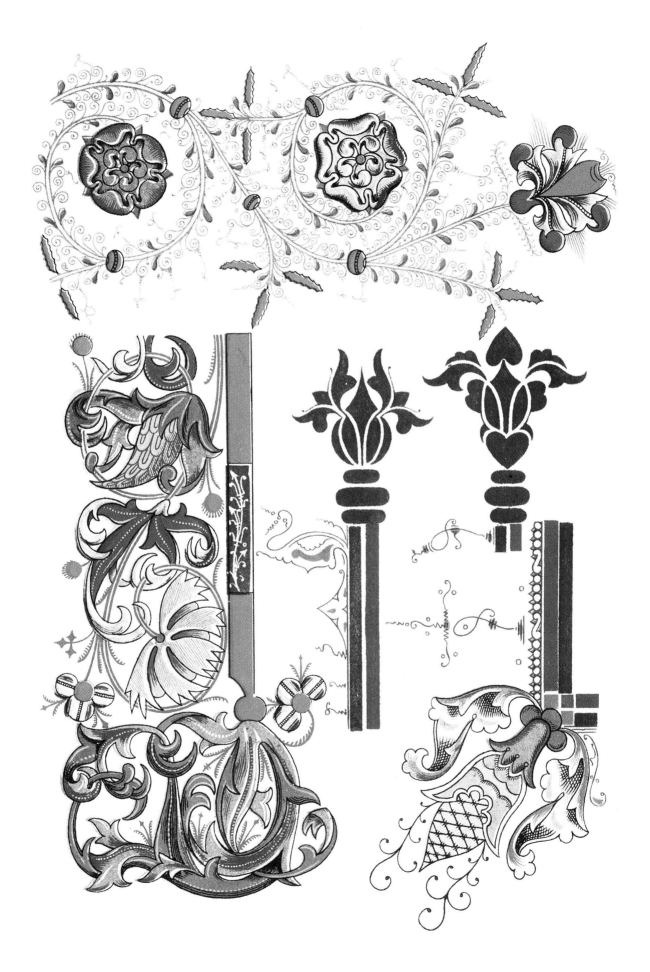

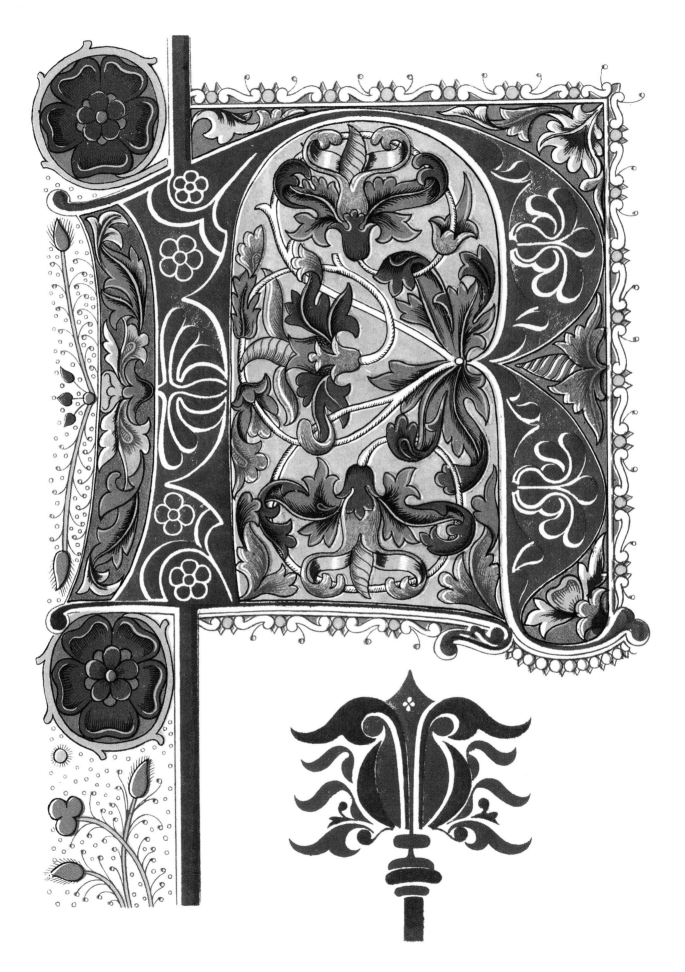

Plate 38 *Fourteenth Century*

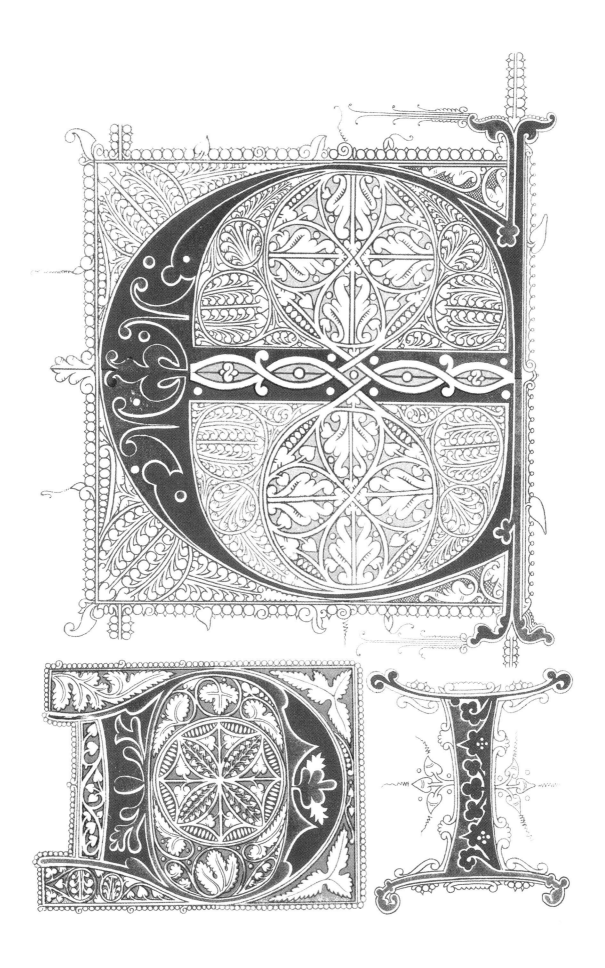

Plate 40 *Fourteenth Century*

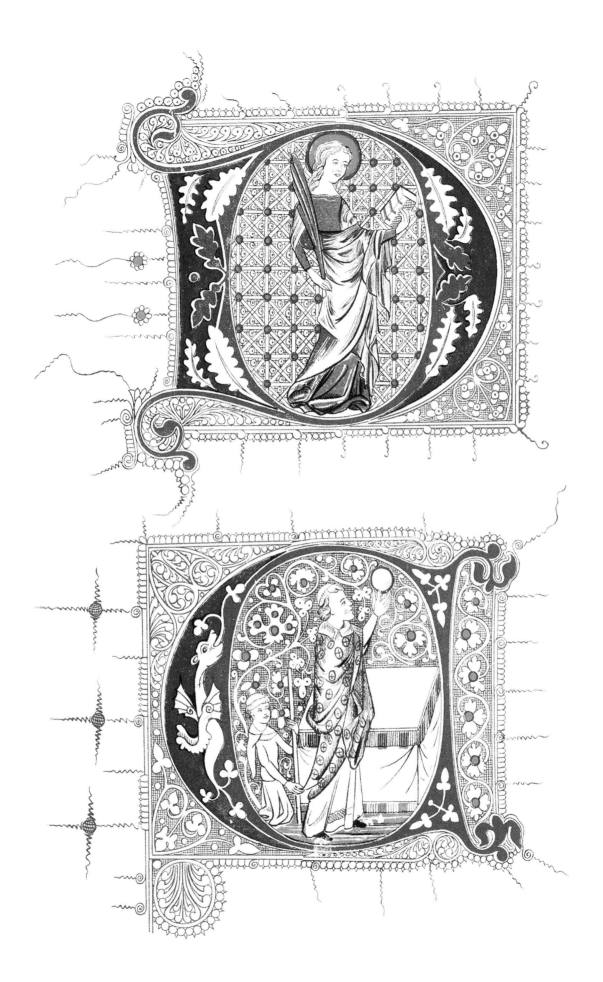

Fourteenth Century Plate 41

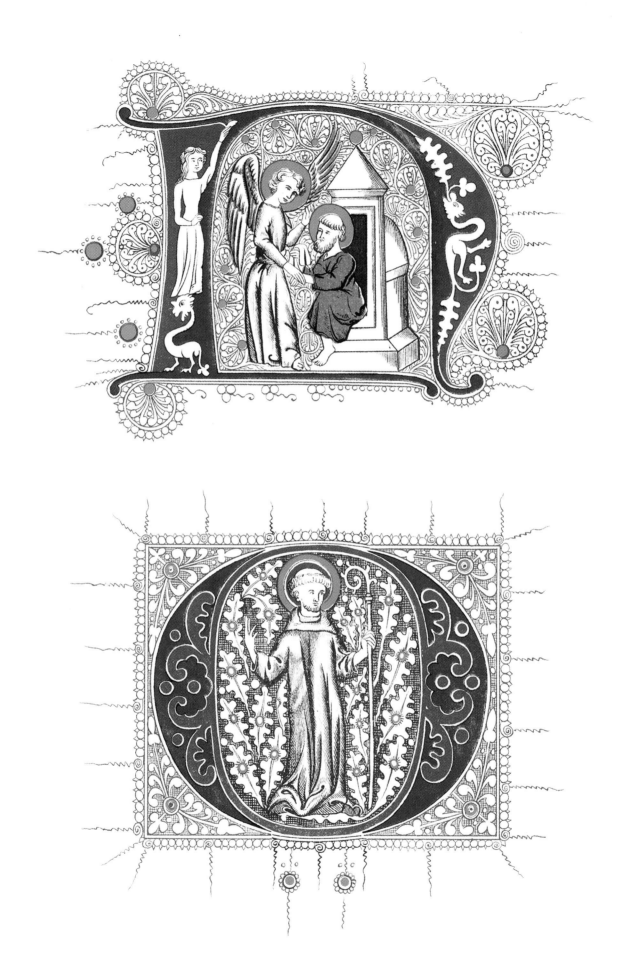

Plate 42 *Fourteenth Century*

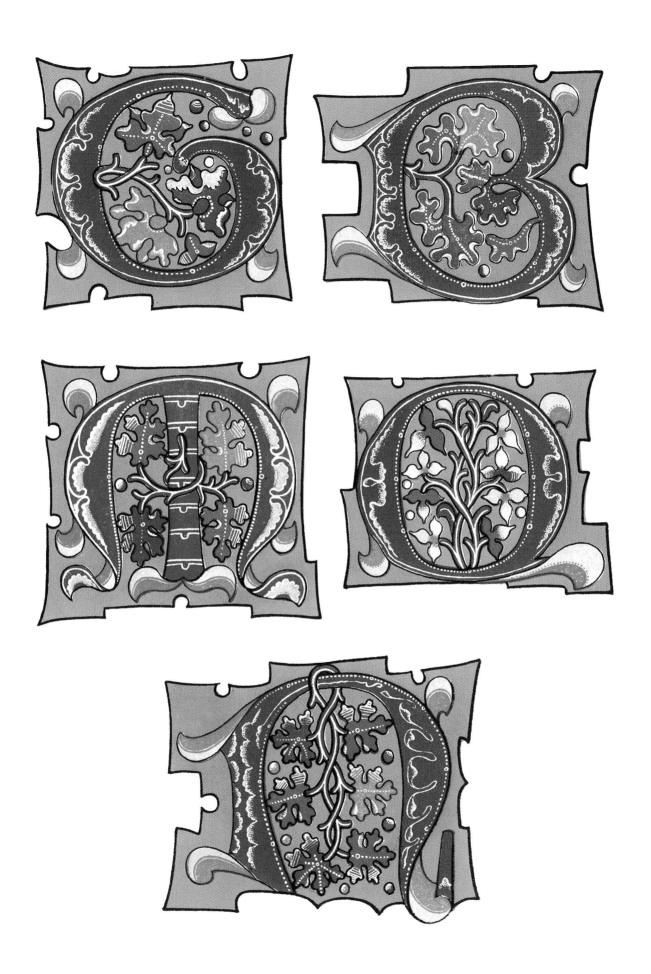

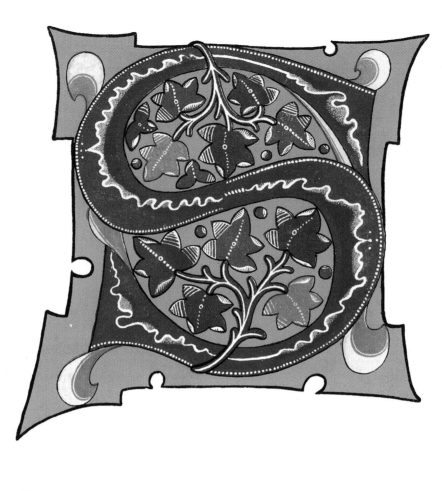

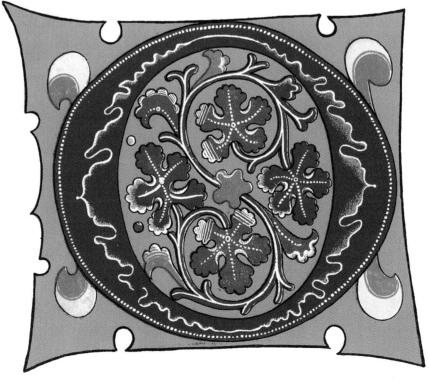

Plate 44 *Fourteenth Century*

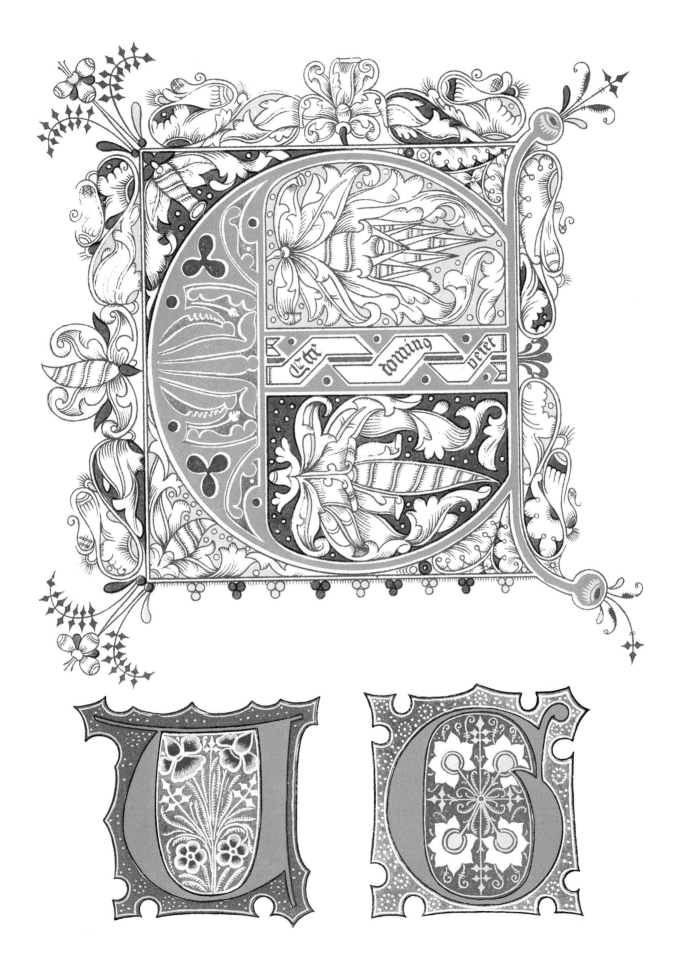

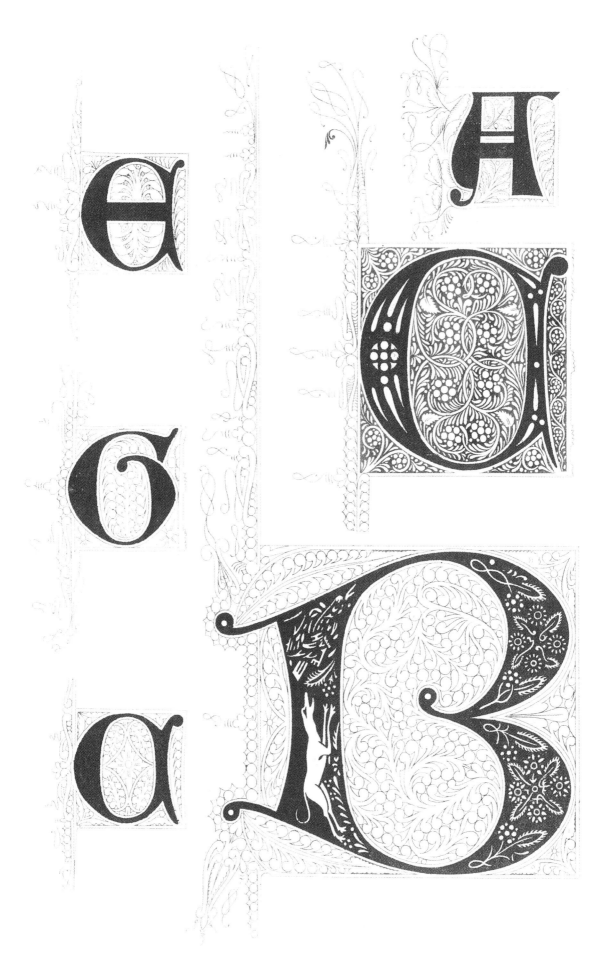

Plate 46 *Fifteenth Century*

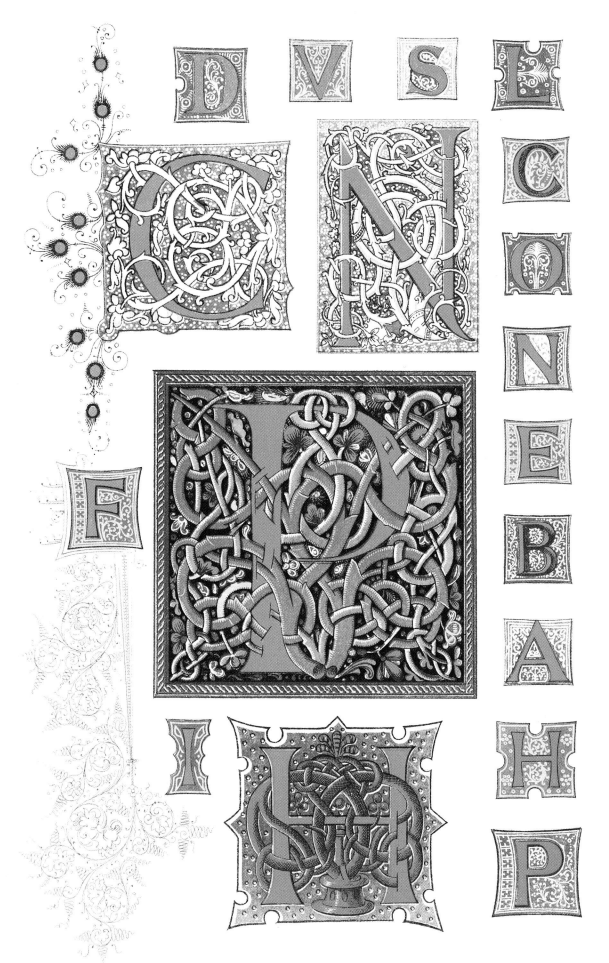

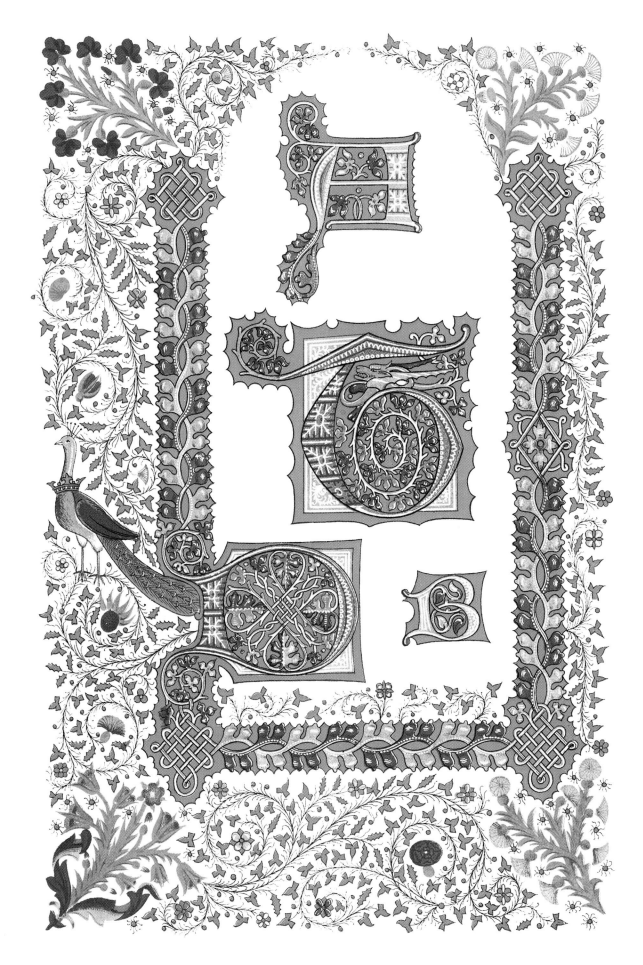

Plate 48 *Fifteenth Century*

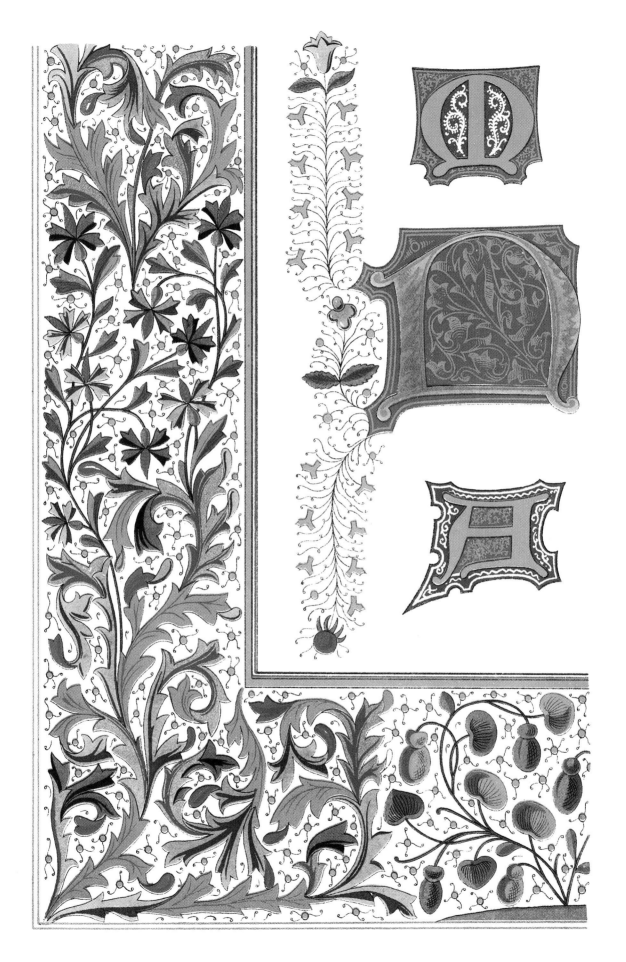

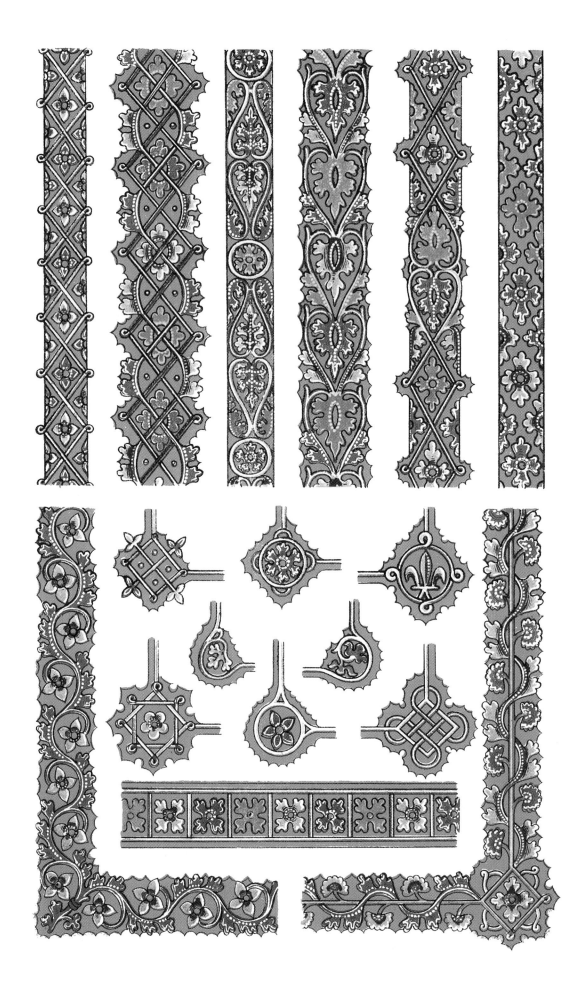

Plate 50 *Fifteenth Century*

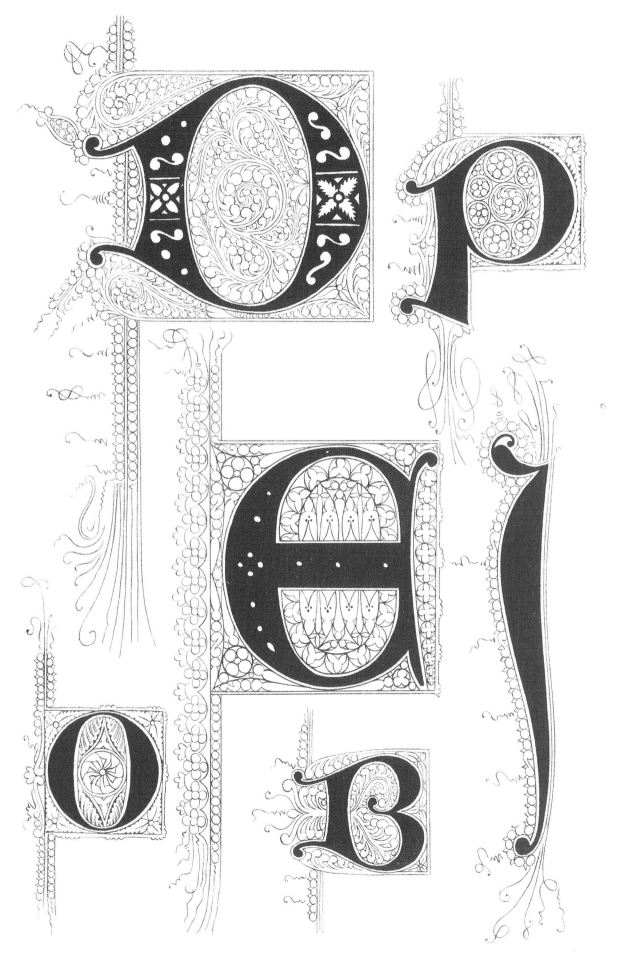

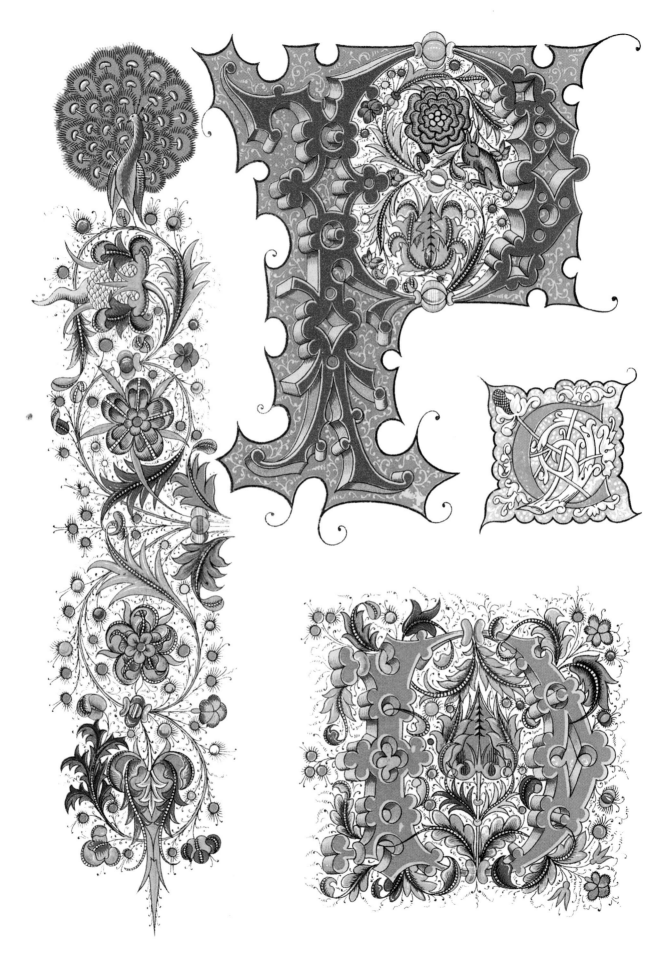

Plate 52 *Fifteenth Century*

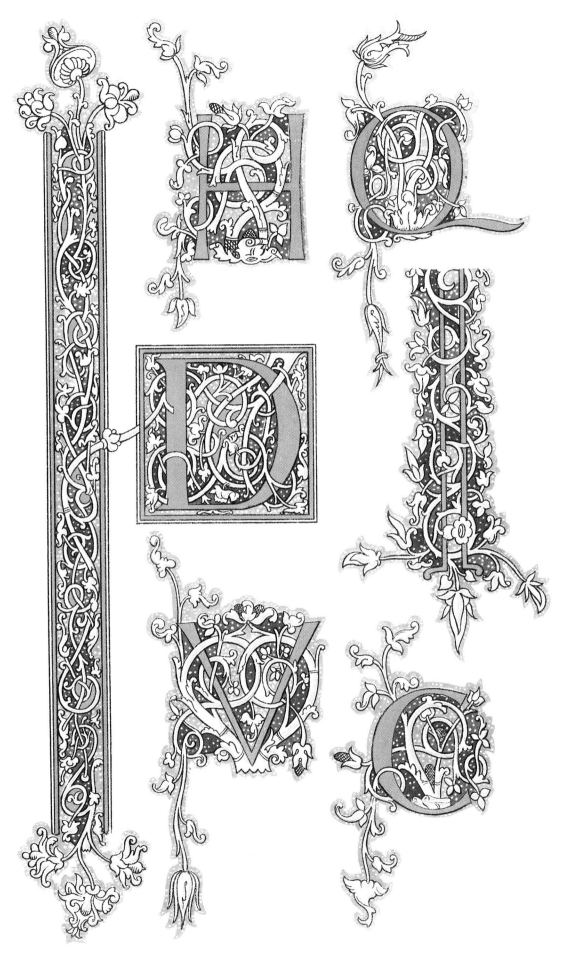

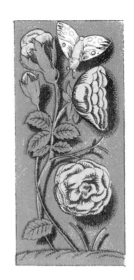
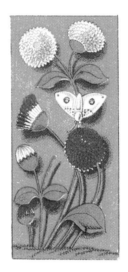
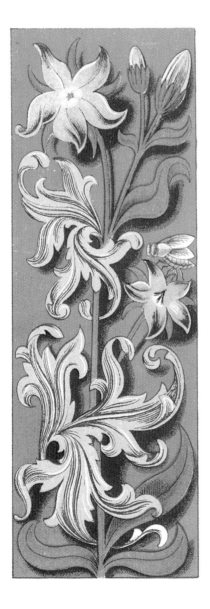
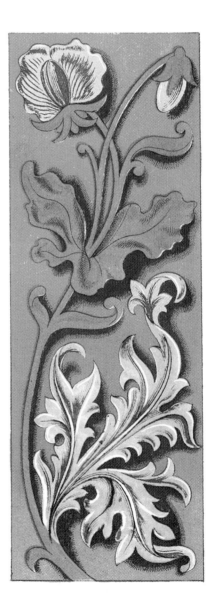
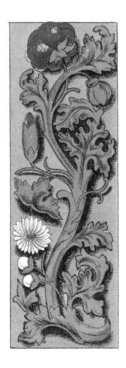

Plate 54 *Sixteenth Century*

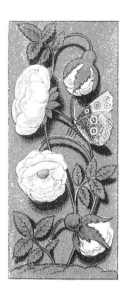
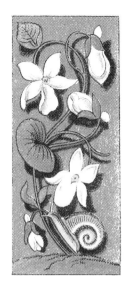
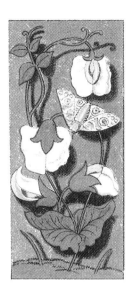

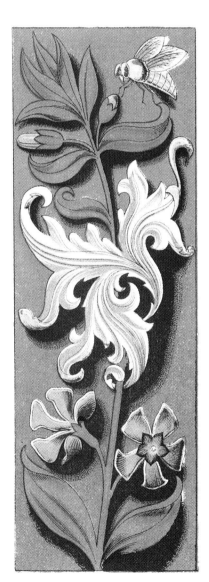

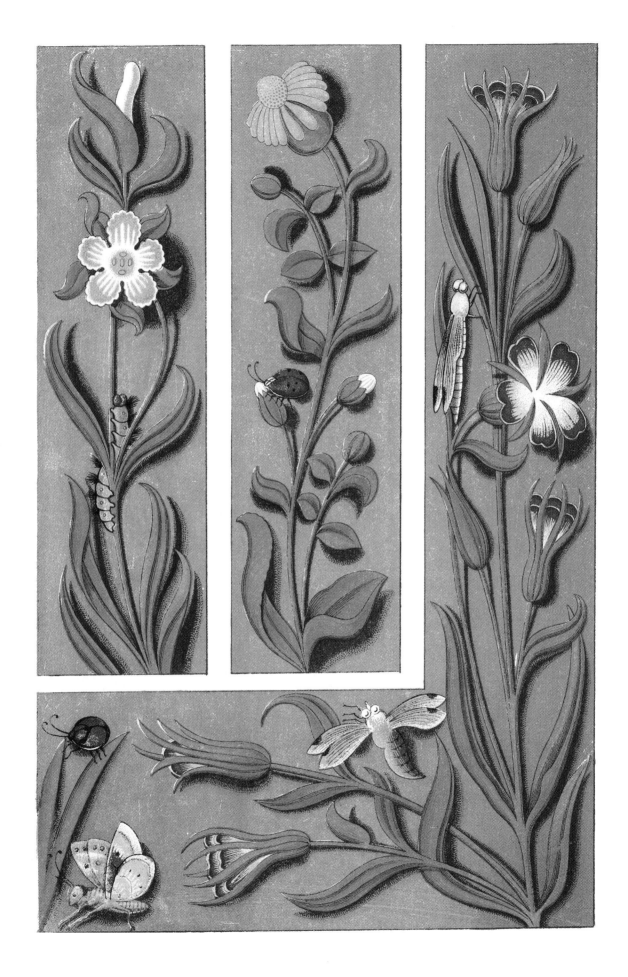

Plate 56 *Sixteenth Century*

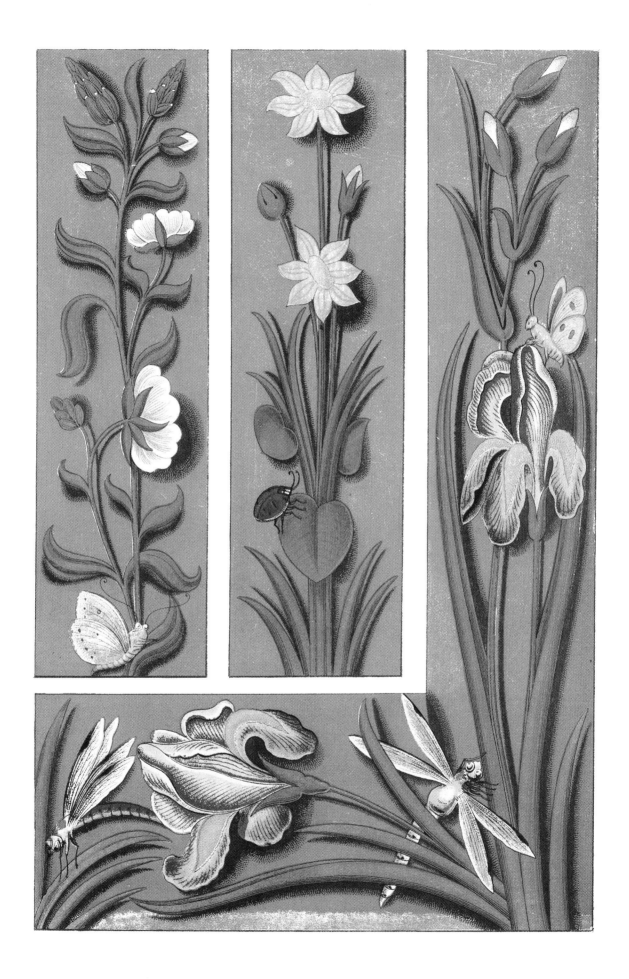

Sixteenth Century Plate 57